I draw, I paint

markers

Text: Isidro Sánchez
Translation: Edith V. Wilson
Paintings: Vincenç Ballestar
Illustrations: Jordi Sábat
Editorial Direction: José M. Parramón Homs

© Parramón Ediciones, S.A. 1991
Published by Parramón Ediciones, S.A. Barcelona, Spain

The title of the Spanish edition is *Mis primeros pasos en rotuladores*.

All inquiries should be addressed to:
Barron's Educational Series, Inc.
250 Wireless Boulevard
Hauppauge, New York 11788

Library of Congress Catalog Card No. 92-11233

International Standard Book No. 0-8120-1375-1

Library of Congress Cataloging-in-Publication Data

Sánchez Sánchez, Isidro.
 [Mis primeros pasos en rotuladores. English]
 Markers : the materials, techniques, and exercises to teach yourself to
draw and paint with markers / [text, Isidro Sánchez ; translation, Edith V.
Wilson ; paintings, Vincenç Ballestar ; illustrations, Jordi Sábat].
 p. cm. — (I draw, I paint)
 Translation of : Mis primeros pasos en rotuladores.
 ISBN 0-8120-1375-1
 1. Dry marker drawing—Technique. 2. Felt marker drawing—
Technique. 3. Artists' materials. I. Title. II. Series.
NC878.S26 1992
741.2'6–dc20 92-11233
 CIP

Printed in Spain
2345 987654321

I draw, I paint

markers

The materials, techniques, and exercises to teach
yourself to draw and paint with markers

BARRON'S

What are...

Markers for coloring

You probably have already used markers many times, but you may not know the many ways in which they can be used to create wonderful works of art.

This book will help you discover many creative techniques for painting with markers.

Since markers first appeared in the mid-fifties, they have improved spectacularly.

Nowadays the variety of styles and colors is so extensive that markers have become a powerful pictorial tool.

The dramatic illustration on this page was painted with markers. With the techniques you will learn here, soon you will be getting similar results with your markers.

MARKERS COME
IN MANY STYLES
AND COLORS

Basic technique

Because their inks are transparent or clear, the basic technique for markers is similar to that used with *watercolors*. The *transparent color* of a fresh coat of marker ink will allow pencil lines or other colors previously applied to show through.

However, unlike watercolors, markers don't have to be mixed with water before applying them. You need only the marker itself.

Aside from being a process that requires few materials, the basic marker technique has other characteristics:

- Light colors must be applied first for better results.
- As a rule, white markers are never used; the white background of the paper provides the color for the white areas.
- Colors are mixed by superimposing two or more colors.

FIRST, APPLY THE LIGHT COLORS

THEN, APPLY THE DARK COLORS

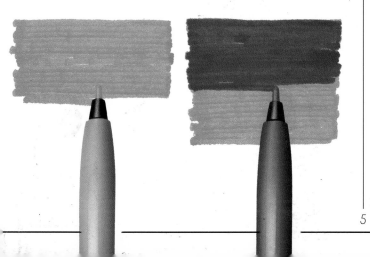

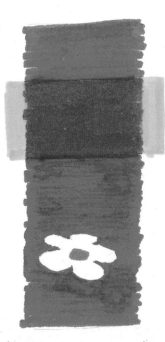

The words appearing in *italics* are defined in the Glossary at the end of this book.

MARKER COLORS ARE TRANSPARENT
If, for example, you use a yellow marker over a blue background, you will obtain a green color.

YOU MUST RESERVE AN AREA ON THE PAPER FOR THE WHITE ELEMENTS IN YOUR PICTURE

What I draw with...

What is a marker?

Markers are handy containers for colored inks. Inside, they have a wick made of *felt*, an absorbent material that holds ink. A porous *nib* is inserted in the wick to transfer the ink to the tip, which is shaped to work as an applicator or kind of brush. When not in use, the nib is covered with a cap to keep the ink from evaporating.

Types of markers

- **The ink.** Markers are available with two kinds of ink: solvent-based or water-based.
 Solvent-based inks dry faster than water-based inks; for this reason, they are widely used by professionals in graphic design for storyboards and illustrations.

INTERNAL STRUCTURE OF A MARKER
A. Reservoir D. Applicator tip
B. Felt wick E. Supporting head
C. Internal nib F. Cap

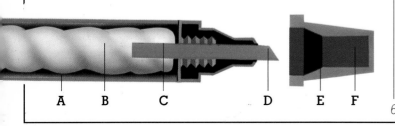

A B C D E F

- **The nibs.** There are three main types of tips:
 1. Fine-point markers, which are used for outline drawing or to fill in small areas.
 2. Bullet-point (medium or wide) markers, which make medium to wide lines and are suitable for filling in medium-size areas.

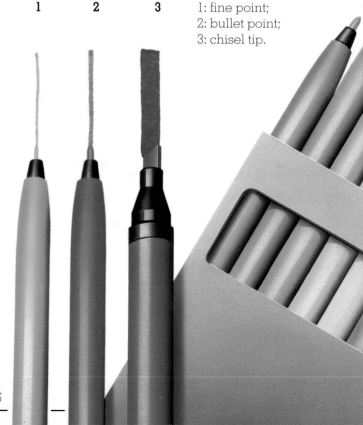

1 2 3 1: fine point;
 2: bullet point;
 3: chisel tip.

3. Chisel-tip (medium to wide) markers, which are excellent for making lines of different widths and for filling in large areas. The exercises in this book can be done with water-based, medium-sized, bullet-point markers.

A basic color collection

It is not necessary to buy an expensive set of markers with many colors. A more sensible (and inexpensive) way to acquire a marker collection is to buy single markers with water-based inks of medium quality.

In this way, you will be able to build a basic collection of colors that will be sufficient for you to begin creating beautiful pictures with markers.

To begin, a collection of 12 markers will do nicely. The set should have light and dark tones, or intensities, as in the set shown at left. It is better to have various tones of the same color than to have too many different colors. Buy additional markers as you need them.

YOU ALSO NEED TO HAVE A FEW CHISEL-TIP MARKERS (SHOWN AT LEFT) WHICH SHOULD INCLUDE THE THREE PRIMARY COLORS: YELLOW, BLUE, AND RED.

What I draw with...

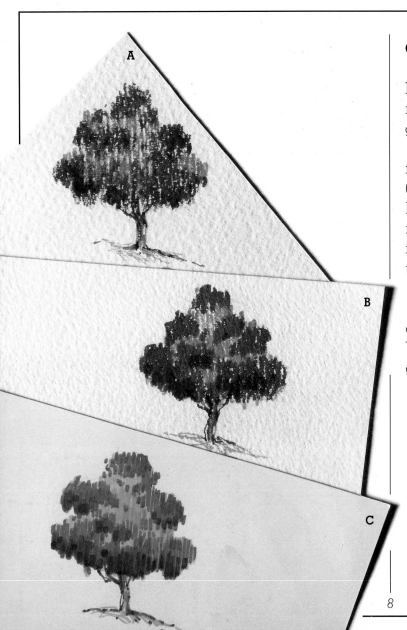

General features of paper

Many varieties of paper are sold, but the two main features by which all papers are distinguished are weight and texture.

To determine the weight of a paper, manufacturers weigh a certain number of sheets (usually 500) of a certain size (usually 2' × 3'); however, a smaller number and size of sheets may be used to determine the weight, depending on the type of paper. You can assume that the heavier the paper, the thicker it is.

Texture, or grain, refers to the coarseness or smoothness of the surface of the paper. There are fine-, medium-, and coarse-grain papers. You can also find very smooth papers with no grain at all.

Papers A and B are coarse and don't work well with markers. The papers with a satin (no grain) finish (C) or with a fine grain work best.

What paper should I use?

The ideal paper to use with markers should have the following features:

- **It must be fairly smooth**, that is, without grain or with fine grain.
- **It must not be too absorbent**, so the ink will not run on the surface.
- **It must hold the ink**, so the color can be extended before the ink dries.

In other words, you must select papers that are smooth and of a medium thickness. You can buy paper in single sheets or in pads of various sizes.

Special papers

Some manufacturers have created pads especially for markers; these work well with both water-base and solvent-base markers, and come in several sizes. The sheets consist of a glossy top layer, a spongy middle layer, and a waterproof bottom layer. Parchment paper pads (also available in several sizes) and Bristol board (available in large sheets of one to five ply) are also suitable.

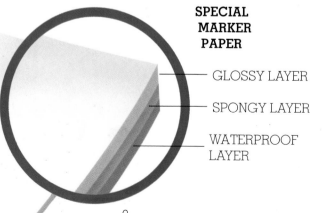

SPECIAL MARKER PAPER

— GLOSSY LAYER

— SPONGY LAYER

WATERPROOF LAYER

Paper made especially for markers has three parts:

- **Glossy layer,** which lets the marker glide smoothly over the surface.
- **Spongy layer,** which absorbs the ink.
- **Waterproof layer,** which stops the ink from going through the paper.

What I paint with...

Marker holders

While you work, you will need to have your markers handy. Having to reach into a drawer or a case every time you need a color can be tiresome, and loose markers cluttered on your table or desk can get lost. An easy solution is to put your markers into two holders. You can choose any kind of container you like.

Why two holders? Selecting the colors will be easier if you use the holders to separate your markers into *cool colors* (greens, blues, violets) and *warm colors* (yellows, oranges, reds, carmines, and earth tones). Perhaps this suggestion may not seem important to you, but it can save you a lot of time.

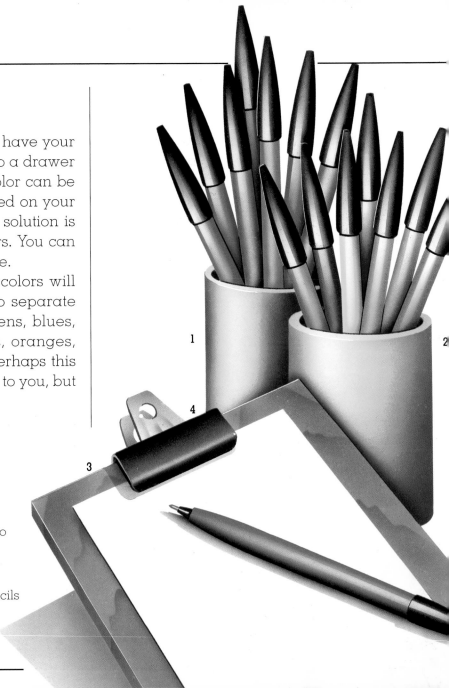

1. Holder for cool colors.
2. Holder for warm colors.
3. Wooden drawing board.
4. Metal spring clip to hold the paper on the board.
5. An eraser (to use when pencil sketching).
6. Thumbtacks to fasten large papers to the board.
7. Graphite pencils for drawing.
8. Sketch pad.

Wooden drawing board

For your convenience, get an 18 × 24-inch (45 × 60 cm) wooden drawing board to which you can fasten your paper or pad.

Stand the board on your knees and lean it against the edge of a table; this will let you work more comfortably.

Keep in mind that an uncomfortable working position can have a bad effect on your final results.

Metal clip and thumbtacks

A metal clip, similar to the one shown in the illustration, will be useful to hold small sheets of paper on the drawing board. Use thumbtacks to hold large sheets of paper.

Pencils

Marker inks do not cover pencil lines. So do your drawing with a hard (H) or medium (HB) *graphite pencil*—commonly known as a lead pencil—which produces faint lines. Do not bear down too heavily.

Eraser

A rubber or kneaded eraser will come in handy when working with graphite pencils.

Sketchbook

You will need a small pad to make sketches on before working on the actual paper for your drawing.

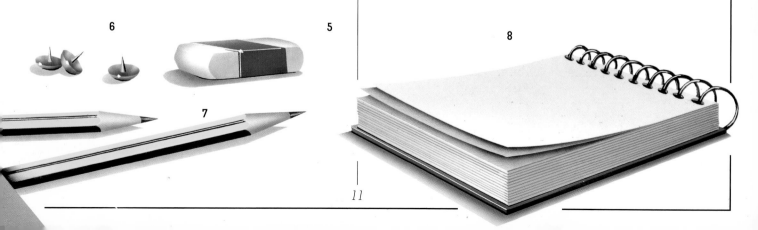

6 5

7

8

How I paint...

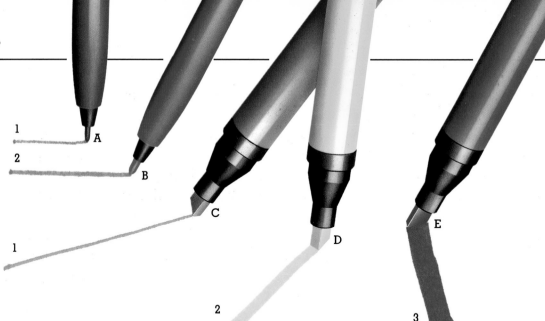

Bullet-tip markers (A and B) make thin (1) or thick (2) lines. With the wide-tip markers (C, D, and E) you can get lines of different widths depending on which part of the nib you paint with: the edge (1), the beveled surface of the chisel tip used the narrow way. (2), or the beveled surface of the tip used the wide way (3).

Holding the marker

The way you hold your marker depends on the type of line you want to make.

If you want to draw fine lines, hold the marker as though you were going to write. However, to color a background or a large area, it is better to take the back of the marker inside your hand and hold the marker with all five fingers.

Bullet-tip markers

If you put a bullet-tip marker upright on its tip, the stroke will be as thick as the width of the nib. If you slant the marker so that the nib touches the paper at an angle, the strokes will be wider and will cover larger areas.

Wide-tip (chisel-tip) markers

Different types of strokes are possible with wide-tip markers (also called chisel-tip markers), depending on the part of the tip that you use:
- By using the edge of the nib you can draw fine lines.
- If you use the beveled surface, the lines will be thick.
- By placing the beveled surface sideways on the paper, you can fill in backgrounds or large areas.

Two suggestions

- Move the marker across the paper without bending your wrist. Only by moving both the arm and the marker as if they were one unit will you be able to make unbroken lines.
- Slide the marker on the paper surface with smooth, even movements and without stopping. This will keep you from applying more ink in some areas than others.

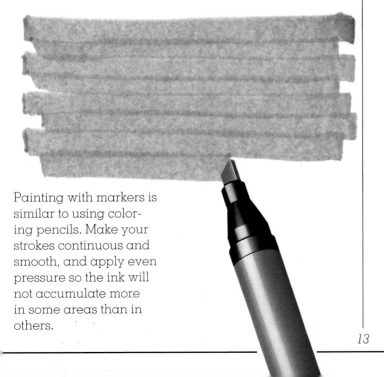

Painting with markers is similar to using coloring pencils. Make your strokes continuous and smooth, and apply even pressure so the ink will not accumulate more in some areas than in others.

Marker ink is not erasable

The ink from a marker penetrates the paper as soon as it is applied; this makes it almost impossible to remove.

If immediately after coloring an area you try to remove the ink with an eraser, you probably will only succeed in reducing the tone slightly. The color can never be completely removed, and erasing can damage the paper.

It is not a good idea to remove marker ink with an eraser. If you need to correct an error, the eraser can reduce the color intensity in a small area. However, erasing usually leaves an unwanted ring around the erased section and may even damage the surface of the paper.

How I paint...

Painting an evenly colored background

Practice the following technique for applying an even layer of color to a large area.

With a pencil, draw a 4 × 4-inch (10 × 10 cm) square. Holding your marker at a slant, make horizontal (left to right) strokes to fill in the square with color. Stay within the pencil lines.

Each new stroke must be joined to the previous one. Apply the color with an even pressure on the marker; you must work fast to get an even tone throughout before the ink has a chance to dry.

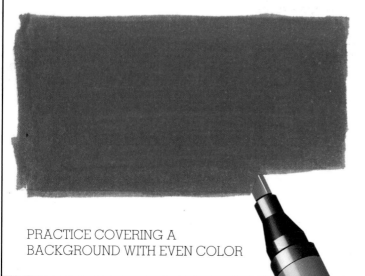

PRACTICE COVERING A
BACKGROUND WITH EVEN COLOR

Darkening tones with one color

The transparency of marker ink lets you gradually darken the tones of any color by superimposing layers of the same color.

Try this test.

Draw another square and color it evenly.

Apply a second layer of color to an area in the square to darken it.

Now superimpose one last layer of color to part of the darkened area; as you can see, the section that received three layers has the darkest tone.

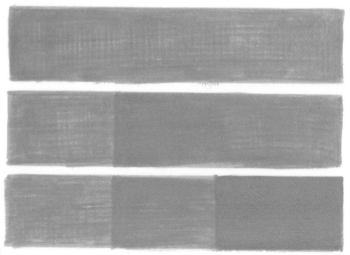

Parallel and sweeping strokes

In working with markers, a simple way to apply the color is with open strokes.

The parallel stroke technique consists of painting several stripes, one alongside the other.

Parallel strokes are always drawn in one direction—usually vertical (from top to bottom) or horizontal (from left to right).

You will need to fill many practice sheets before you are skilled in this technique; try not to let your strokes overlap.

Sweeping strokes are also parallel lines. The difference is that with each stroke you must try to follow the contour or shape of whatever you are drawing.

Look at the examples on this page and then draw the geometric shapes, using both types of strokes.

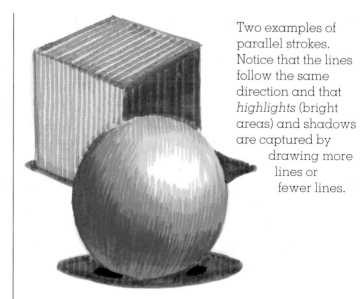

Two examples of parallel strokes. Notice that the lines follow the same direction and that *highlights* (bright areas) and shadows are captured by drawing more lines or fewer lines.

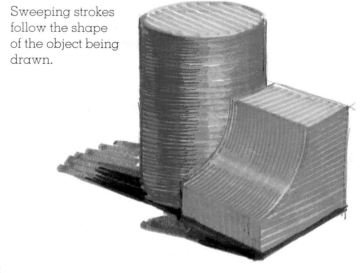

Sweeping strokes follow the shape of the object being drawn.

How I paint...

Creating a gradation

Working with markers differs from using coloring pencils because you cannot make a color lighter or darker by putting more or less pressure on the marker (as you could do with coloring pencils).

How, then, can a gradation—a smooth change in tones—be achieved?

As you already know, a certain amount of tone can be obtained by applying more than one layer of the same color. For a richer effect, however, you can superimpose various tones of the same color. This is why it is good to have as complete a range of tones as possible.

Try making a gradation like the one shown here. First, draw a rectangle with pencil; then color it with a light tone.

Before the ink dries, paint over a section of the rectangle with a darker tone, superimposing one layer over the other. Then color the area where the dark and light tones meet with another layer of the light tone to "join" or blend the two tones.

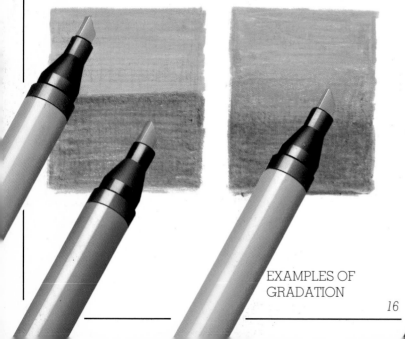
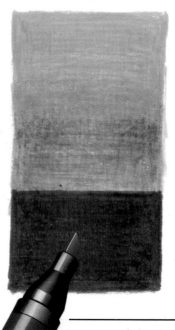
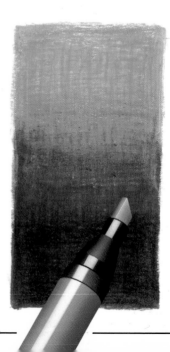

EXAMPLES OF
GRADATION

Color blending

The technique of blending is used to soften the change between two tones of a color used side by side. It is also useful for covering the spaces left between parallel strokes.

Blending can only be done when the ink is still fresh on the paper—that is, before the first layer has dried. For best results, go over the colors you want to blend as many times as it takes for the change in tones to look gradual.

Preventing mistakes

If you go beyond the area you intended to blend and accidentally paint over a previous layer of another color, your mistake may give you a color you did not want.

To avoid making errors, you can follow these easy steps:

- First, with a hard pencil, lightly outline the limits of each area to be colored.
- Next, go around the pencil line with the marker color you will be using there.
- After the ink has dried, color the entire area you have outlined with the marker.

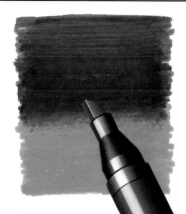

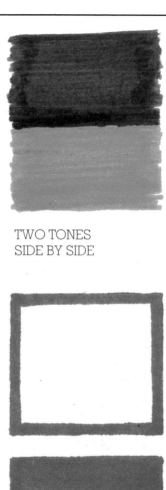

TWO TONES
SIDE BY SIDE

BLENDING THE
TWO TONES

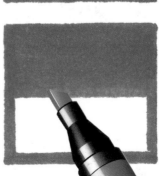

1

2

WAYS TO AVOID
MISTAKES IN
COLORING
1. Outline the area to be colored with the marker.
2. Fill in the entire space outlined in Step 1. Following this technique when appling different colors to your drawing will help you avoid unwanted overlaps of colors.

Color...

Mixing colors

The technique for mixing two or more colors with markers is to superimpose them—that is, to paint one color over another.

On a sheet of practice paper, try mixing the colors in your collection in all of the combinations you can think of. You need to know every possibility your markers offer you to obtain the best possible results.

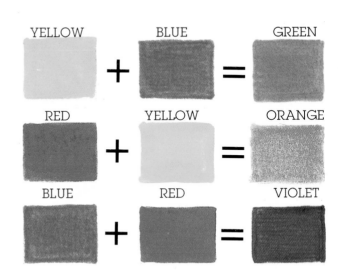

The three primary colors

Your marker collection must include the three basic or *primary colors:* blue, red, and yellow. You can mix them in various combinations to obtain all the colors found in nature.

If you mix the primary colors in pairs, you will get green, orange, and purple, which are known as *secondary colors.* If you combine the primary with secondary colors, you can also create six *tertiary colors:* yellow-green, yellow-orange, red-orange, red-violet, blue-violet, and blue-green.

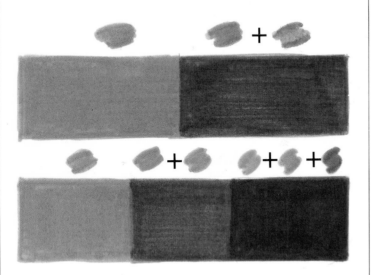

Top: The result of the mixture of two colors.
Bottom: The colors created by adding a third color.

The color wheel

The color wheel is also known as a *chromatic circle*. It is used to show the relationship between colors. For example, the colors that are opposite each other on the wheel are considered *complementary colors*.

To the left are the secondary colors—green, orange, violet—which are created by mixing two of the three primary colors.

Secondary colors (S) are obtained by mixing the two closest primary (P) ones. Tertiary colors (T) are created by combining a primary color with the secondary color that follows, either to the right or left.

To the right is a color wheel, which is made up of 12 colors—the three primary colors (P), the three secondary colors (S) (made by mixing primary colors) and the six tertiary colors (T), which are the result of mixing a primary color with a secondary color.

The arrows within the wheel relate the primaries with their opposite complementary colors. When used next to one another, these colors provide the greatest contrast.

My first exercises...

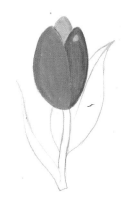

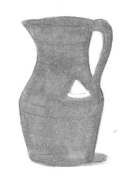

Make a drawing of this simple flower with a hard graphite pencil.

Go over the outline of the flower with a bullet-tip marker. Then fill in the color.

Draw this vase; clearly show its shape and the limits of the shadow and the highlight areas.

Fill the color in with parallel strokes. Leave the highlight areas white.

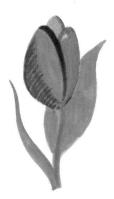

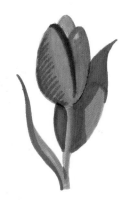

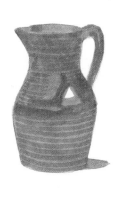

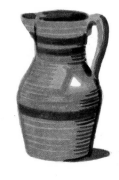

Follow the same steps to do the leaves. Be careful not to overlap the colors of the flower and the leaves.

Add darker strokes (don't blend with the underlying color). Do the same with the lighter tones.

Now use sweeping strokes to put in the shadows and the darker tones.

To finish, intensify the areas of shadow and go over the horizontal strokes to give the vase volume.

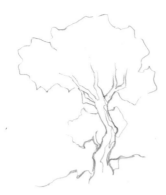

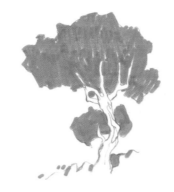

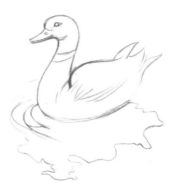

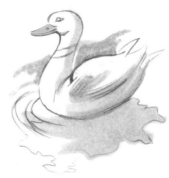

Continue practicing your parallel and sweeping strokes. Draw the basic shapes you see here.

Apply a first layer of color to the treetops and the shadow areas on the ground.

Copy the duck, and include the reflections in the water so that the areas of color will be clearly marked.

Begin coloring with a light tone; don't worry if you go over the pencil lines.

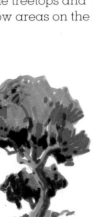

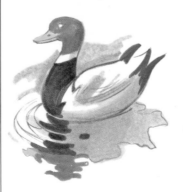

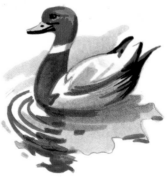

Use yellow ochre for the background foliage and trunk. Add a few strokes of ochre over the green.

Finish by darkening the shadows in the foliage and on the tree trunk.

Now, apply dark tones to the head, neck, and feathers. Begin a simple gradation in the reflection.

Emphasize a few strokes in the water. Do a full gradation in the duck's head and the reflections.

My first exercises...

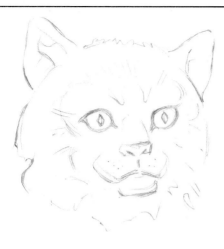

Draw the cat's outline without pressing too hard on the pencil. Always remember that the greater the detail in a sketch, the easier it is to color it.

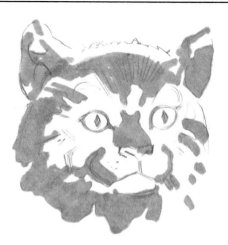

First, apply the overall color, using the outline as a guide. With a fine-tip marker, draw the contours of the eyes, nose, and mouth.

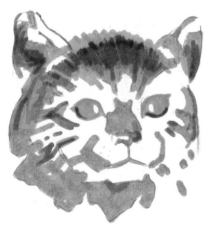

Note how you can blend and harmonize the colors by superimposing lighter tones over previously applied colors.

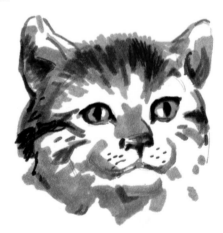

Finally, intensify certain strokes—the eyes, the base of the nose, some spots on the fur—with a black bullet-tip marker.

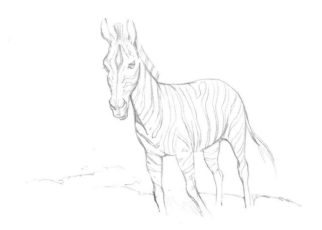

Draw a zebra, using this model as a guide. Include the important details of the face as well as the stripes in the body.

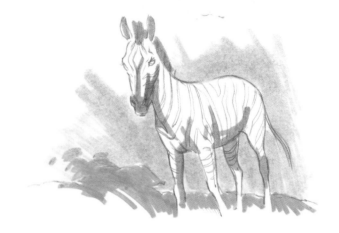

Use bullet-tip markers—slanting them to draw with the side of the nib—and apply the first few strokes of color to the background, the zebra, and the ground.

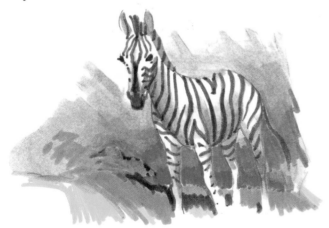

Now fill in the zebra's stripes, holding the marker upright. Then apply blue to the background and yellow to the ground. Blend them into the previous colors.

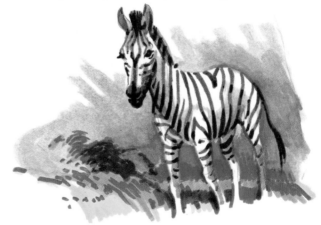

All that remains now is to darken the shadows and to obtain gradations by blending the dark with the light tones.

My first exercises...

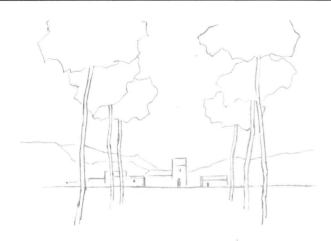

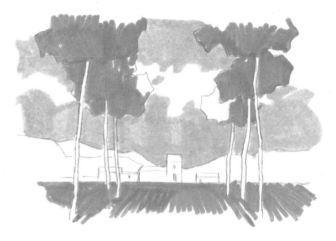

In this landscape you will practice the parallel stroke technique, without color blending. First, copy the drawing in as much detail as possible.

Next, apply the first few strokes of color, being sure to hold the tip of the marker flat against the paper. Always work in the same direction.

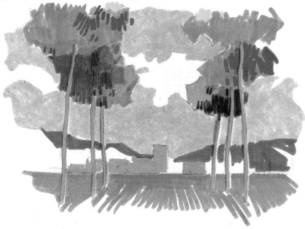

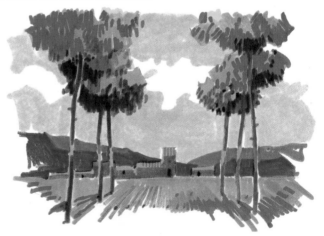

When painting the mountains, houses, and tree trunks, be careful not to overlap the colors. Then paint the treetops with dark green and yellow ochre.

For the final step, continue using parallel strokes to darken the tones to create the shadows.

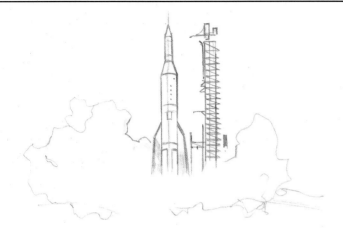

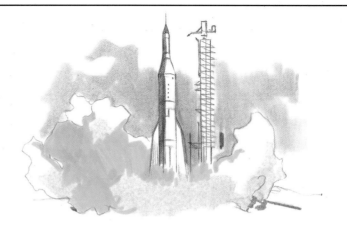

With this exercise you will get spectacular results. As before, outline the limits of the color areas in your drawing so that later you can concentrate on coloring.

Apply the light colors first, holding the tip of the marker flat against the paper. Then, make a stroke down one side of the rocket with a darker shade.

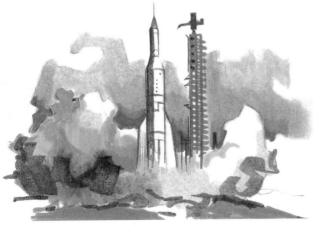

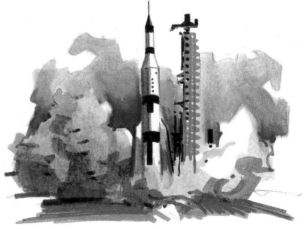

Now you can show how well you have learned the technique of blending. To get this result, you must create each gradation by applying light over dark tones.

For the finishing details you need to keep working with the dark tones and blending the light tones in to obtain a smooth transition.

My first exercises...

It is important that you draw a detailed outline as you see here. It is a useful guide when the time comes to apply the colors.

In the next few pages you will find exercises for practicing everything you have learned about painting with markers.

Try to follow each suggestion regarding the colors and techniques you should use.

In this first exercise you will be able to practice the parallel stroke.

26

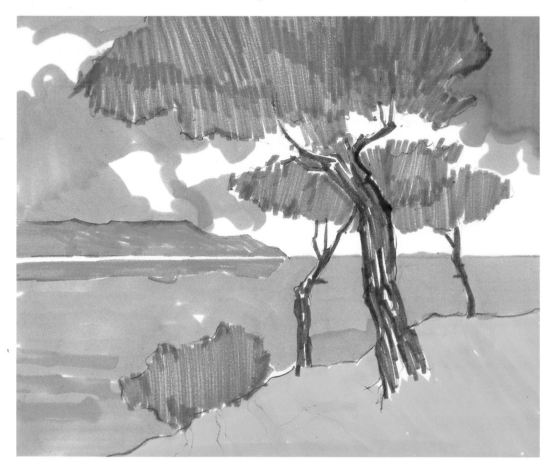

First, color the background and the large surfaces. Use wide-tip markers to paint the clouds, the silhouette on the horizon, the sea, and the small land area in the foreground.

Always move the marker in the same direc-tion, using even pressure and continuous motion to keep the ink from accumulating in some areas.

Then, color the tops and trunks of the trees with bullet-tip markers.

My first exercises...

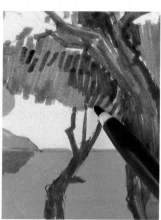

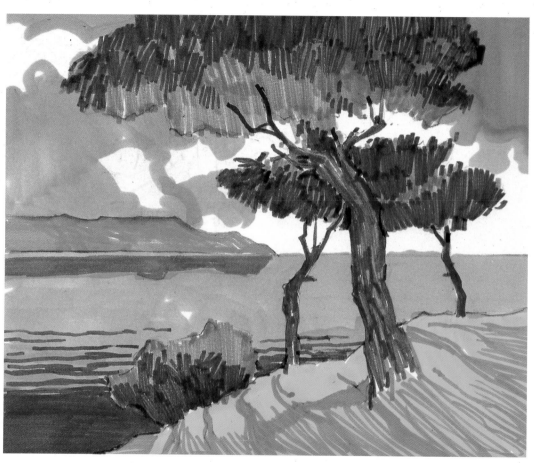

Keep working the tones.

For the sea, completely color the bottom area on the left and then add a few separate strokes.

Do the same in the foreground to create the shadows of the trees.

Finally, still using parallel strokes, color over the previous strokes to add the shadows in the tops and trunks of the trees.

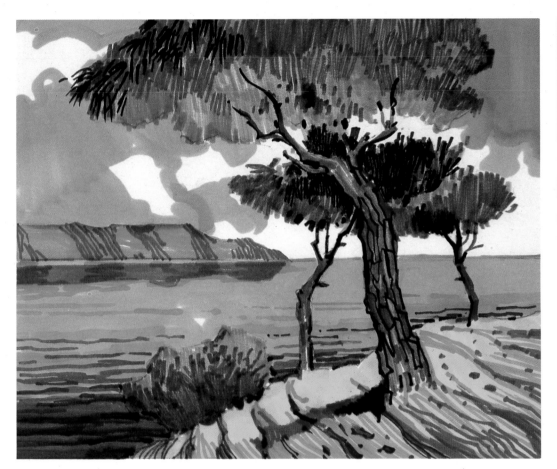

This exercise is an excellent example of the parallel stroke technique: strokes of different colors painted side by side.

Look at your picture. The finishing touches now depend on what you think your work needs.

This means that you must not follow our model stroke by stroke. It is you who must judge what areas of your picture need more work to obtain a satisfactory final result.

My first exercises...

When sketching the base of the marker holder, you must draw a complete oval—not just the semicircle that we see.

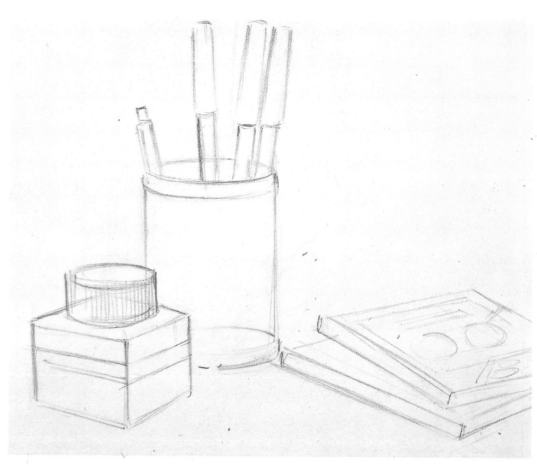

A detailed drawing is half the work in making a picture. As a second exercise we offer you this simple still life. Drawing it should be easy for you.

Use a hard- or medium-grade graphite pencil, press lightly and avoid too many erasures so as not to smudge the drawing.

If your pencil lines are too dark, remember that the ink from the marker will not cover them.

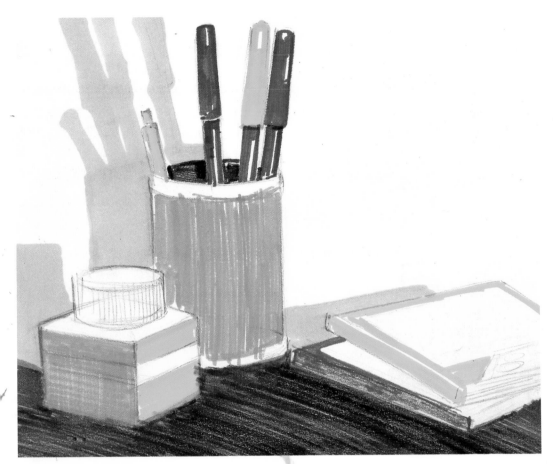

Begin by painting the background. First, color a layer of light green. Use quick strokes, moving the marker in the same direction. Next, use gray to create the shadows of the ink bottle, the marker holder, and the books.

Then paint each object, keeping in mind that you must outline the limits of each area before coloring it entirely.

Now, make a simple color combination: apply brown over the light green layer.

My first exercises...

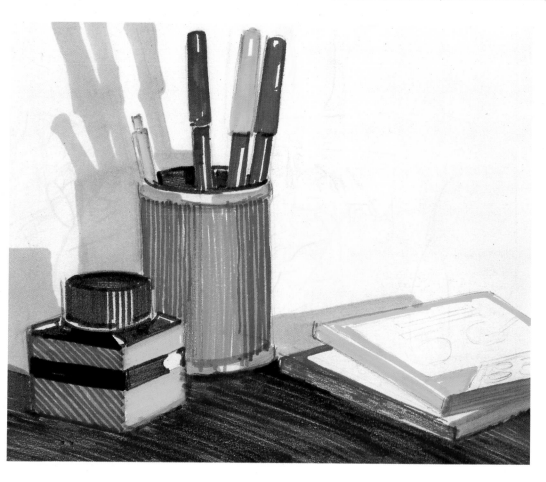

Continue applying colors, layer over layer, until you become skilled at superimposing colors. Paint parallel strokes in the marker container. Making them all in the same direction helps create the illusion of volume.

Now paint the rest of the ink bottle with a black marker.

Then apply a few soft strokes of gray to the sides of the books.

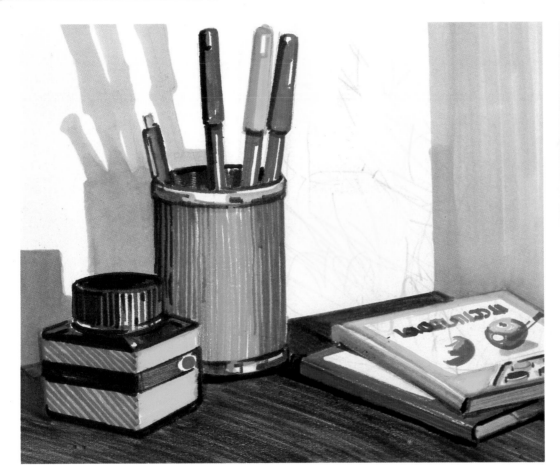

Observe how you can obtain more intense shadows in the left side of the stripe and on the upper part of the ink bottle by superimposing black over gray.

All that remains to complete the picture is to strengthen some of the strokes with a black marker.

With a bullet-tip gray marker, add more color to the shadows of both the ink bottle and marker container.

As a last step, color the backs of the books with green and violet. Add a mere hint of the title and the illustration on the cover of the top book.

My first exercises...

Draw complete ovals for the wheels of the car. You can erase the un- wanted lines later.

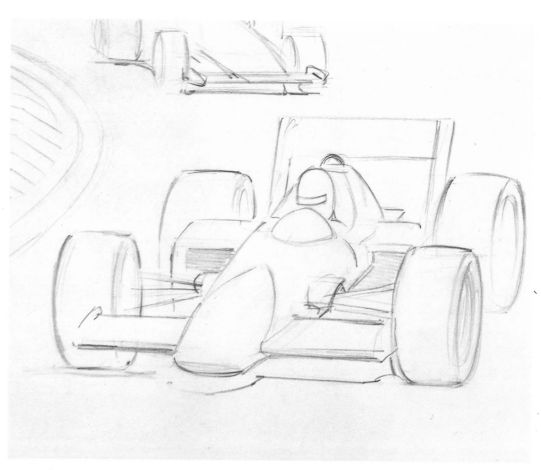

Make a detailed copy of this drawing. It is not as difficult as it looks.

Begin with a sketch of the basic shapes of the objects (especially of the body of the car in the foreground) and the wheels. Look closely at the model drawing and try to get the correct *proportions*. If you first sketch the form and proportion of your subjects, it will be easier later to draw the details.

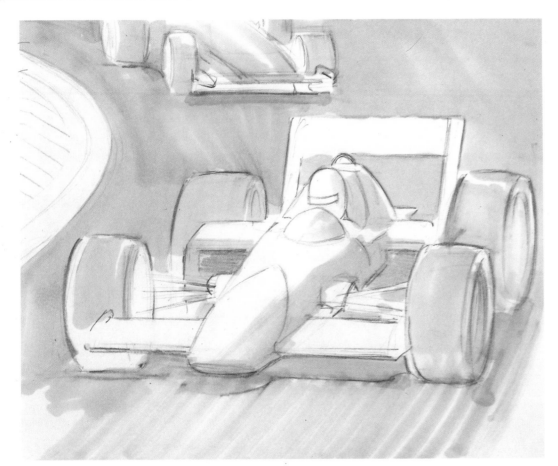

In this step you must show that you can paint large backgrounds evenly, without any breaks in the color. This will be easier if you have practiced the appropriate exercises in the previous pages.

Use one of your wide-tip markers.

Press the nib sideways against the paper to color the large areas. Use the edge of the tip to outline the shapes.

My first exercises...

Remember, always outline the outer limits first and then color the entire area.

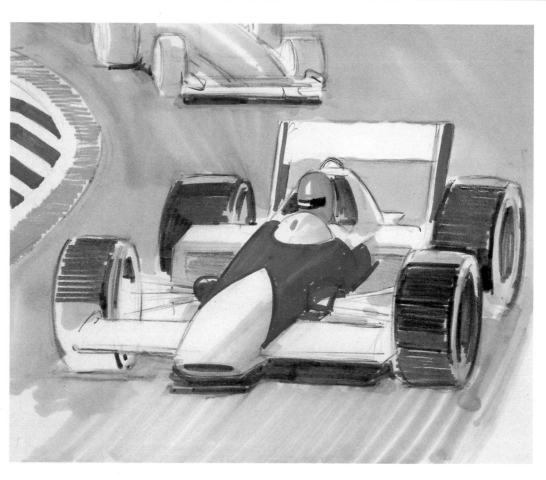

You now need to use a bullet-tip marker to color the body of the car, the wheels, and the stripes on the road.

Paint the circular road stripe, using strokes that gradually become more separated.

Finish this step by coloring the shadows of the cars with your black marker. Also use this marker to make the horizontal strokes on the wheels of the car in the foreground.

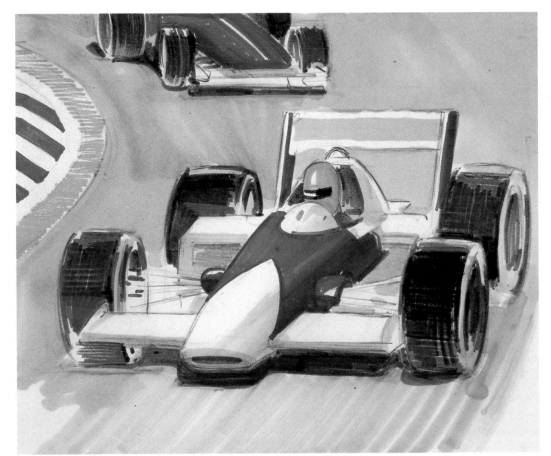

Now you are going to superimpose colors as you have learned to do in the previous pages.

Add red to the shadows of the car in the foreground, then add blue to the body of the car in the background. Finally, paint vertical strokes on the wheels with a blue bullet-tip marker.

Adding strokes in a different direction lets you intensify the tones and cover the blank spaces.

My first exercises...

The color in this area doesn't need blending. The red strokes should contrast with the underlying color.

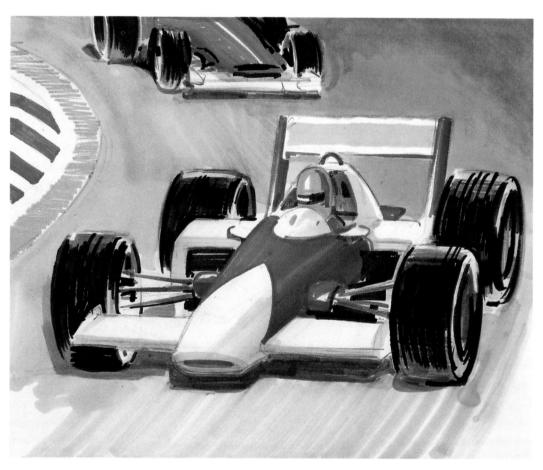

In this part of the exercise you will use black and blue almost exclusively.

Use the wide-tip marker to make your first blend in the upper-right corner of your picture. Press down on the marker until the blue blends with the first layer of color.

Then make a few vertical strokes with the black bullet-tip marker on the wheels and near the body of the car.

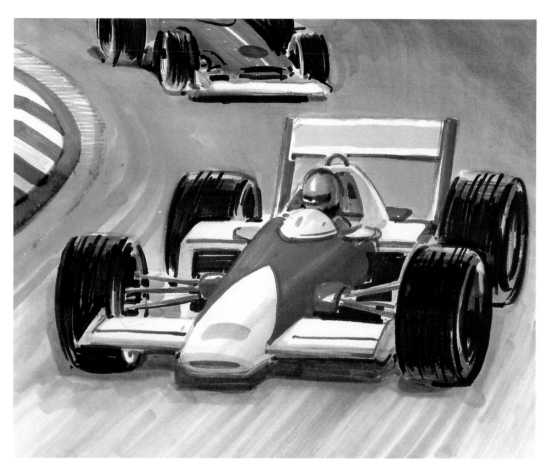

Keep using the blue wide-tip marker to color the background.

Make a green stripe on the left side of the picture and darken one edge of the stripe with several layers.

To complete this exercise, use the blue bullet-tip marker to color some of the white spaces on the wheels and to paint a few strokes on the pavement to give the illusion of speed.

My first exercises...

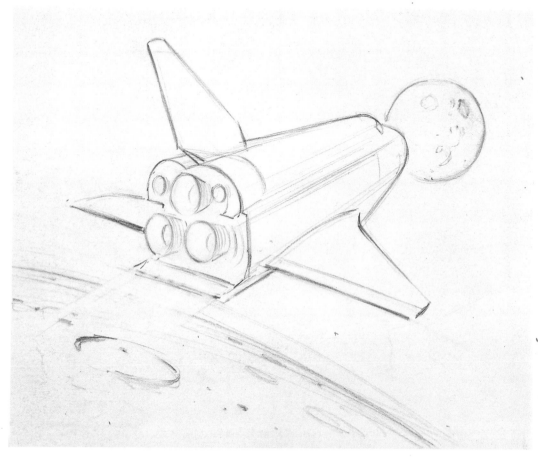

Be careful when coloring, especially while working the area around the space shuttle; outline every shape carefully.

This last exercise will let you apply everything you have learned. If you have practiced the different techniques explained in this book, you will easily complete this exercise and obtain results that will make you proud of your work.

First, draw the sketch shown in the model.

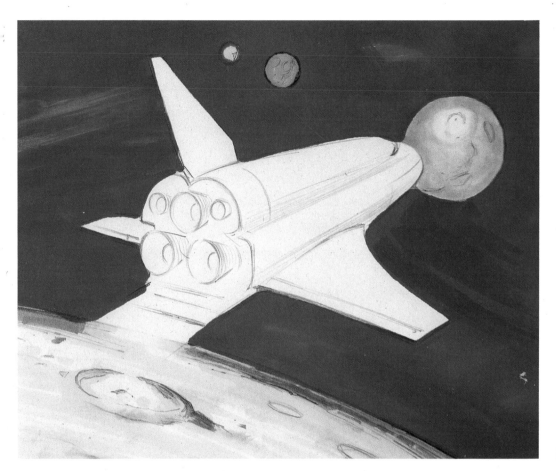

As you have learned, color the large surfaces first.

Use one of your wide-tip markers to paint the area of outer space; paint quickly and carefully. Do not apply too much ink near the limits of the space shuttle and the planets.

With a bullet-tip marker, apply a first layer of color to the surface of the planet in the foreground.

My first exercises...

To paint the luminous trail that the space shuttle leaves behind, draw your first strokes close together and then wider and wider apart.

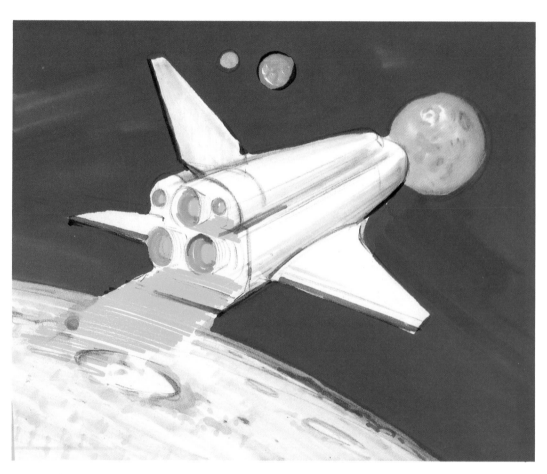

Once you have painted the background, begin applying the first notes of color.

Outline the space shuttle with yellow ochre and dark brown.

Now, use light tones to paint the craters of all the planets (both in the foreground and background) and the rockets on the space shuttle.

Use bullet-tip markers, slanting them to press the side of the nib against the paper.

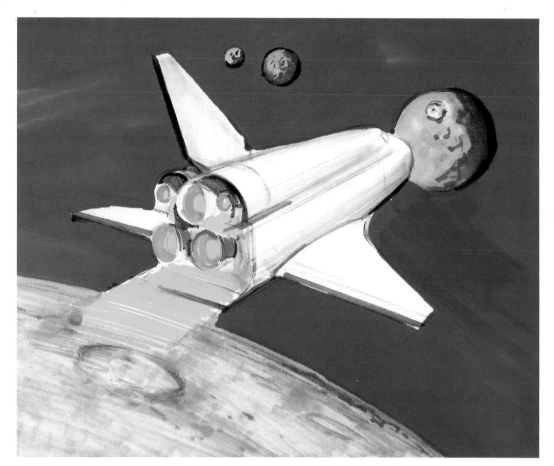

Now begin working on the dark tones of the space shuttle by applying layer after layer of color.

With black, emphasize the shadows on the planets in the background.

Add more color to the surface of the planet in the foreground. Use a light tone and do not press the marker heavily against the paper.

My first exercises...

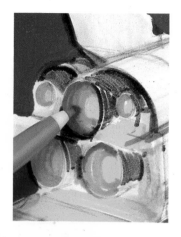

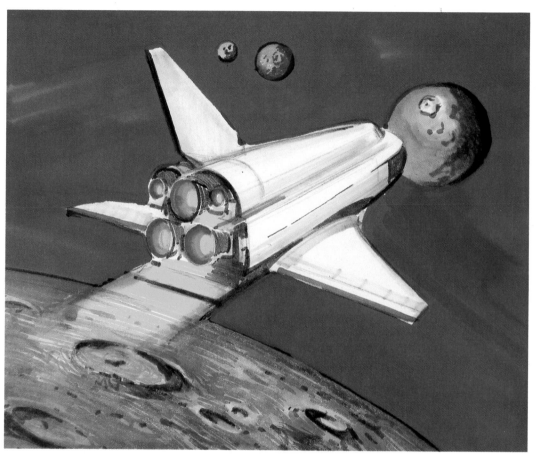

You now need to work on all the colors to blend them with the underlying layers.

Reapply the light tones as many times as it takes to blend the gradations, especially in the rockets of the space shuttle.

The planet that is in front of the space shuttle needs gray in the shadow areas. Blend the tones well to obtain the illusion of volume.

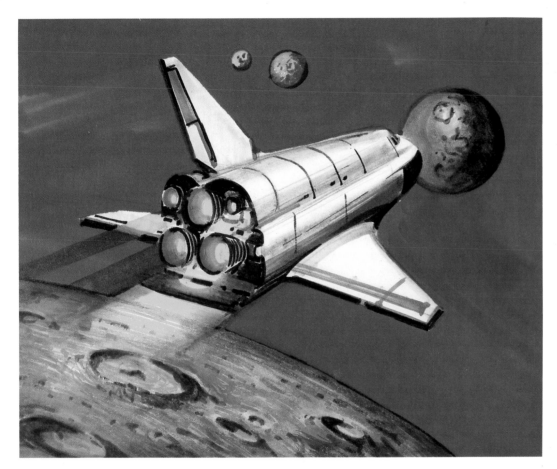

Remember: With markers, gradations cannot be done with more or less pressure against the paper. It is necessary to use different shades and then blend them by using a lighter tone over them.

Keep working on all the colors, blending each tone with the other.

Darken the shadows even more on the planet towards which the space shuttle is pointed, then paint the area behind the rockets with yellow. See how this gives a certain glow to the entire picture.

Did you ever imagine that a few markers could help you make such a terrific picture?

Glossary

chromatic circle. A circle made up of twelve colors: three primaries, three secondaries, and six tertiaries. Another name for chromatic circle is color wheel.

complementary colors. The secondary colors obtained by mixing two primary colors; these are then said to be complementary to the third primary color left out of the mixture (for example, green, obtained by mixing blue and yellow, is complementary to red)

cool colors. Those that in the color wheel are located between green and violet, with both these colors included.

felt. A nonwoven material made with animal, plant, or synthetic fibers. In markers, felt acts as a wick to absorb and transport ink.

form sketch. Preliminary lines in a drawing that set down the basic forms of a subject by means of simple geometric shapes (squares, rectangles, circles, etc.)

gradation. The gradual shift from a darker tone to a lighter one or vice versa.

graphite pencil. A drawing and writing instrument, commonly called lead pencil. It comes in different grades of hardness that range from 9H—the hardest—to 8B—the softest—with HB and F being intermediate grades.

highlights. Areas of maximum luminosity reflected off a lighted body or object. In painting with markers, the areas of a drawing left without color to show the white of the paper or colored in the lightest tones.

nib. The felt tip of a marker.

perspective. Lines drawn on a two-dimensional surface (such as paper) to give the impression of a third dimension (that is, depth).

primary colors. Red, blue, and yellow: the colors that are blended to produce any other color, but that cannot themselves be obtained by any mixture.

proportions. Basic measurements (sometimes expressed as formulas) that help capture the correct dimensions of an object or model. For example, a guiding formula for drawing the

human body is to divide it vertically into eight equal sections from the top of the head to the feet. Each section approximately equals the distance from the top of the head to the chin.

reserve. To leave areas without color, using the background color of the paper. This produces white or lightly colored areas in the picture.

scale. A group of all the tone variations in a color.

secondary colors. Orange, violet, and green; the colors obtained by blending pairs of primary colors.

sketch. A simplified drawing or painting in which the shape, composition, and tonal values of light and shadow are roughly determined.

tertiary colors. The colors obtained by blending a primary and a secondary color (example, blue-green or red-orange).

tone. Intensities of a color, from the lightest to the darkest; any modification of color.

transparent colors. Colors that do not totally cover what is underneath. This feature allows mixing by superimposing colors on top of one another.

warm colors. Those colors in the color wheel that are located between yellow-green and red-violet, with both these colors included.

watercolors. Paints that must be mixed with water before applying them to the paper.

Index